DRAWING WITH *Christopher Hart*

MANGA MANIA™
BLANK BOOK

> Draw Your Own Manga Comic Book!

 Get Creative 6

New York

How to Use This Book

As you flip through this draw-your-own-manga book, you'll notice that it is divided into six separate sections, giving you the option of creating up to six different short mangas. Each section begins with the cover template shown here, where you can draw the cover and add lettering for the title. Use these pages to create the next cover in your original series or to start an entirely new manga adventure.

The rest of the templates in this book provide a framework for creating your very own manga stories. You may find it helpful to fit your stories within this framework, but feel free to experiment! Stretch your drawings across several separate frames if you like. There is no wrong way to go about it. The choice is yours.

For more instruction on how to effectively use panels, angles, speech balloons, and special effects, keep reading.

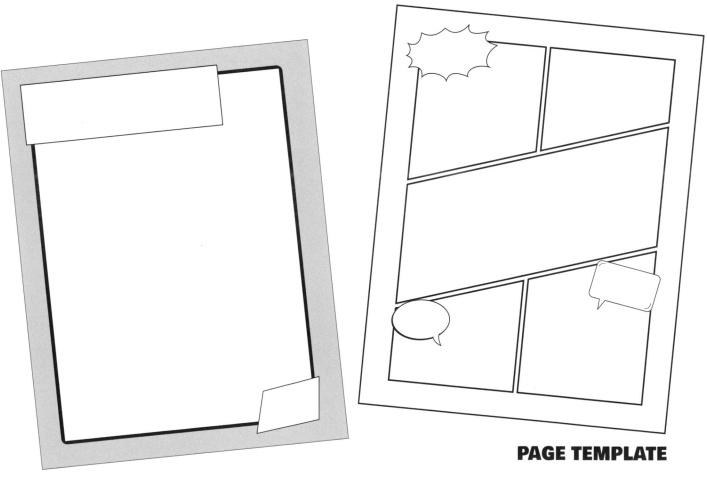

COVER TEMPLATE

PAGE TEMPLATE

FILLING THE PANEL

You can't—and shouldn't try to—squeeze complete figures of both characters into each panel at all times. It isn't necessary, and in this example, it would make the panel so wide that it would end up losing focus and looking empty. But which character do you allow the panel wall to chop in half? As a rule, it's preferable to show all of the far character and cut off the character in the foreground.

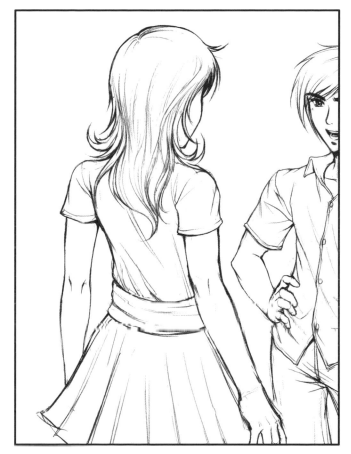

WRONG! Far character is cut off.

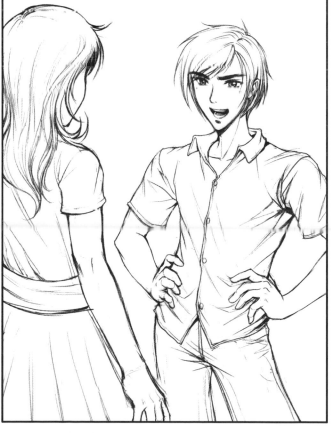

RIGHT! Far character shown in full.

EXTREME DRAMA TAKES EXTREME ANGLES

The Mysterious Boy walks down the hall, but the school athletes block his way. What's he gonna do? This could spell trouble. No one messes with these jocks!

SIDE VIEW

The side view is a good, clear choice. But it's nothing new. In order to heighten the drama, there is not much we can do to the actual drawing itself, which is already very good. For the answer, we'll have to look elsewhere, to the "camera" angle. For extreme drama, we either go below or above the character. But going below (looking up at a character) makes a character appear huge, awesome, and creepy in the eye of the reader. None of those descriptions seem to fit the Mysterious Boy or this scene.

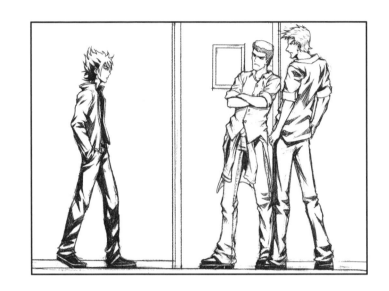

DOWN SHOT

Changing the angle to look down at the characters gives a sense of the surroundings and a feeling that we are observing the situation — perfect! Now we really feel the impending conflict! The tension is awesome. I hope you're now starting to understand the value of choosing the correct angle for the correct moment. You can't get this type of drama from a drawing alone without the correct angle to match it. This is called a "down" shot or a "bird's-eye view."

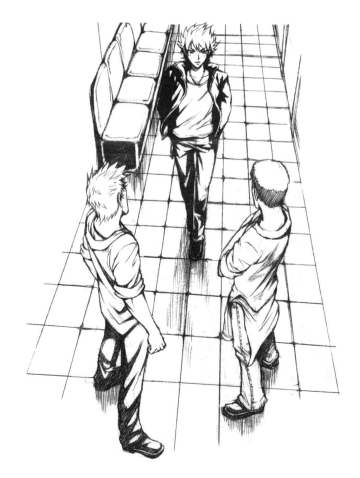

Speech Balloons

The placement of speech balloons is fairly informal in manga, unlike in American comics, where formal principles of layout and composition dictate the approach. However, there are some basic conventions and attractive options for using speech balloons that you can use in your stories. There are three basic heights that work best for speech balloons.

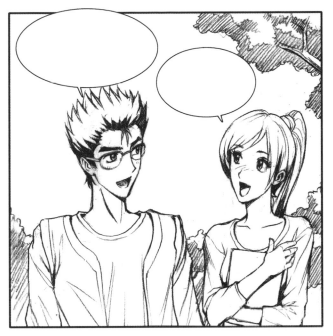

Above the Head

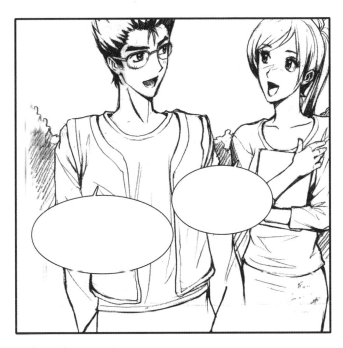

Below the Head

Off to the Side

SPECIAL EFFECTS

Special effects are very important in manga. They enhance the mood, embellish the art, and amplify the state of mind of the characters. And there's one more reason to include special effects: They just plain look cool! The last reason may be the most important of all.

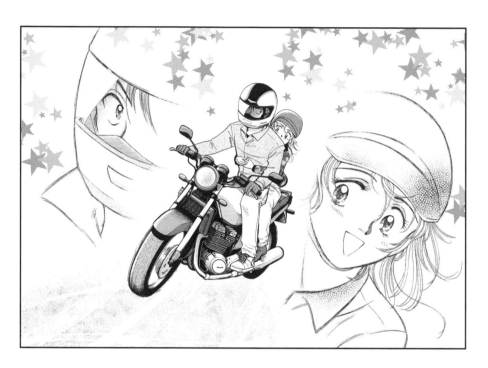

STARS

This is a fanciful effect that gives a carefree, cheerful feeling. It also adds a bit of glamour to a scene. The stars should be gathered in random bunches and trail off, almost like leaves in the breeze. I recommend drawing them freehand with a light gray marker without outlining them in black. This will give them a cool effect, making them look sort of translucent.

REPEATED DOTS

Repeated dots like these are a humorous, abstract design that conveys jealousy. Make sure that the dots radiate from the head, and enlarge the dots as they travel outward. Note, too, that the dots get darker as they get larger. All of this combines to give the effect of an actual stream of dots—or a stream of heated emotions radiating out across the room. Better not mess with her guy!

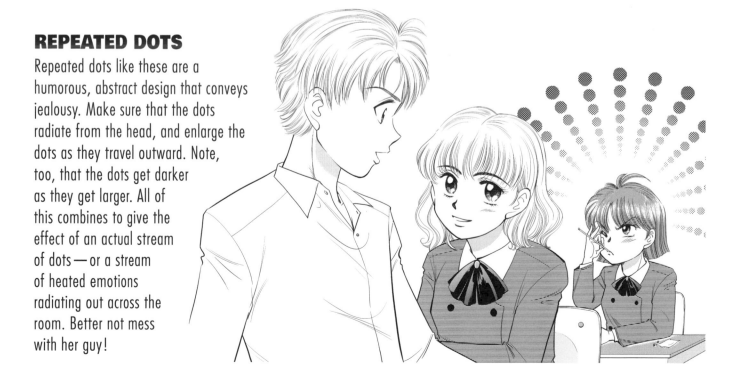

THE BURST

A burst is one of the oldest, most famous, and still most effective types of special effects. It's used for sudden thoughts, outbursts, and sharp emotions. Think of it as a flash of light with characters standing in the middle. In order to show a flash of light, you have to have darkness— right? Therefore, any scene with a burst has to be a dark scene, punctuated with a flash. Keep your burst jagged and uneven.

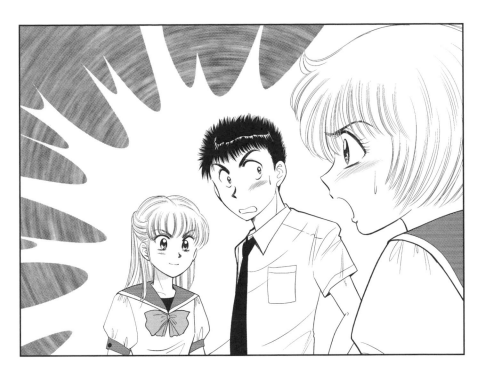

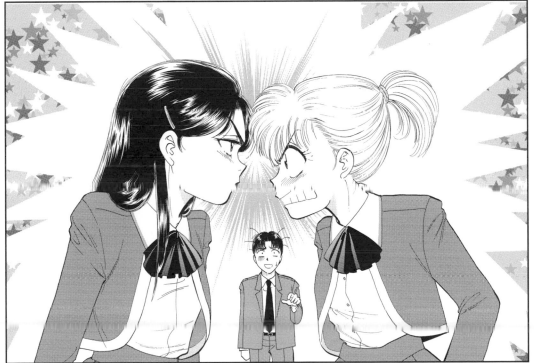

BROKEN SHARDS

Talk about a shattered relationship! Look at those sharp points invading the panel from all sides. Yee-ouch! Looks painful! In addition, there's a mini-burst where their two foreheads are about to collide. Whatever set off the fuse between them, it's about to turn into one heck of an explosion. I think it may—just may—have to do with that boy in the background. If he's smart, he'll stay out of it!

HINT
Note the composition: A boy is standing between them and their friendship, figuratively as well as literally! Often, you can translate the emotional into the visual with basic placement.

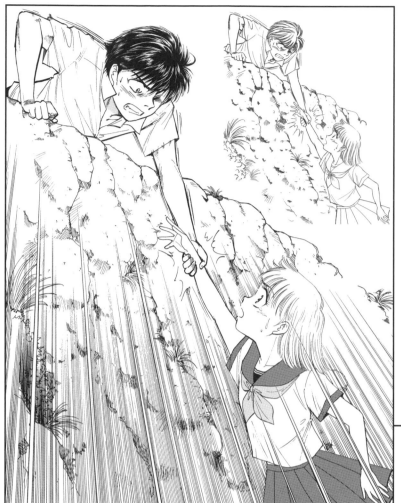

DRAMATIC STREAKS

Streaks equal urgency, which heightens the drama of any situation. But don't let the special effects do all the work. The scene itself has to be exciting, or it's like adding an exclamation point to a boring sentence—the audience won't be moved by it. Notice how the streaks start off darker toward the bottom of the cliff and lighten as they travel upward toward the boy—and safety.

FLASH OF LIGHT

This is a highly dramatic effect—a burst of ethereal light behind a character. It's laying on the drama pretty thick, but when the entire story leads up to one particular scene, you owe it to your readers to pull out all the stops. Notice how all the streaks point to the center of the action. Now you're really directing the reader's eye. As the artist, you're in charge, like a movie director. An evil warlord has killed his girlfriend! This is the worst news anyone could ever get—especially since the prom is only two days away and he doesn't have a replacement date!

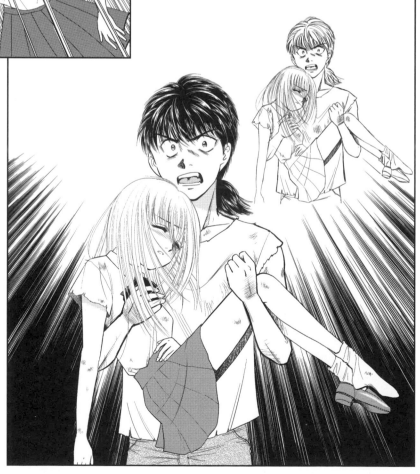

An imprint of **Get Creative 6**
19 West 21st Street, Suite 601, New York, NY 10010
sixthandspringbooks.com

Caution: If children are permitted to use this book, be sure to provide
them with child-safe supplies.

Contributing Artists
ERO-PINKU
TINA FRANCISCO
IZUMI KIMURAYA
TABBY KINK
DIOGO SAITO
NAO YAZAWA

ISBN: 978-1-68462-019-7

Printed in China

5 7 9 10 8 6 4

christopherhartbooks.com
facebook.com/CARTOONS.MANGA
youtube.com/user/chrishartbooks